D1467167

KEEP
CALM
AND
CARRY
ON

·················

THE TRUTH BEHIND
THE POSTER

BEX LEWIS

Published by IWM, Lambeth Road, London SE1 6HZ
iwm.org.uk

ISBN: 978-1-904897-34-7

A catalogue record for this book is available from the
British Library

Printed and bound by Gomer Press

All images © IWM unless otherwise stated

Every effort has been made to contact all copyright
holders. The publishers will be glad to make good
in future editions any error or omissions brought to
their attention.

10 9 8 7 6 5 4 3 2 1

FRONT COVER: IWM design incorporating the
'Keep Calm and Carry On' 1939 poster

BACK COVER: Piccadilly Circus, London, during the
Second World War. War Savings posters surround
the central plinth. Ministry of Information Photo
Division. IWM D9309

Design by Adrian Hunt

CONTENTS

DON'T HELP THE ENEMY!

CARELESS TALK MAY GIVE AWAY VITAL SECRETS

I

POSTERS:
A PROPAGANDA DEVICE

■■■■■■■■■

Over the last decade or so, you may have seen one of the following sayings on a poster, at least one of which will have been bright red, using a recognisable font, and with a crown or similar logo at the top.

- Keep Calm and Carry On Shopping
- Panic Wildly and Run Away
- Keep Calm and Carry Yarn
- Calm You Shall Keep and Carry On You Must
- Keep Corbyn and Carry On
- Och Wheesht and Get Oan Wae It
- Don't Panic, Put the Kettle On
- Keep Calm and Kill Zombies
- Save Water and Drink Champagne
- Brew Up and Sleep In
- Keep Calm and Eat a Sausage
- I'm Irish, I Can't Keep Calm
- Keep Calm and Fake a British Accent

You may have wondered where these came from, and how 'Keep Calm and Carry On' became so popular. This book will tell the story of the original design produced by the British Ministry of Information (MOI) in 1939, and the story of its 21st-century renaissance.

By their very nature posters are ephemeral items, intended for a particular purpose, to be displayed for only a set time and then disposed of. However, 'Keep Calm and Carry On' and other posters from the Second World War – such as 'Careless Talk Costs Lives', 'Coughs and Sneezes Spread Diseases' and 'Dig for Victory' – are well known to this day, by those who have no first-hand experience of the war. Posters often trigger associations with the era in which they were produced. With the Second World War being such a large part of British cultural history, at a time when it was commonly believed that all pulled together in the pursuit of a common purpose, such strong visual messages help us reconnect with that period.

This book examines the poster as a wartime propaganda tool, and then looks at how the government sought to maintain morale in a state of total war. The planning, distribution and reception of the first posters of the Second World War – the series in which 'Keep Calm and Carry On' was produced – is then explored, followed by a look at the rediscovery and legacy of the design in the 21st century.

DEVELOPING POSTERS AS A PROPAGANDA TOOL

The industrialisation and urbanisation of the 19th century created both the need and the audience for methods of mass communication. More consumer goods were produced, and advertising was developing to target the newly condensed urban

market. The modern poster became recognisable in the mid-century, when Jules Chéret, working in Paris as an artist and lithographer, reduced the lithographic printing process to a commercially affordable level. His poster designs were characterised by a simplification of the elements to focus on the main figures, along with a recognition of the importance of lettering.

English illustrator John Hassall, having studied in Paris, brought a simple and brightly coloured style of design back to the UK shortly before the First World War. At this time, the poster was largely seen as an effective tool of commerce, one that was cheap and easy to disseminate. Most publicity was free of direct state control. Posters first really became a tool of government propaganda in the First World War. This was arguably the first war in an age of mass production, mass markets and mass communications. No one knew what kind of war it was going to be or how long it would last, although most expected that it would be 'over by Christmas 1914', rather than the drawn-out war of attrition that it became.

By December 1914 over 1 million British men had volunteered to fight. Many responded to posters and leaflets produced by the Parliamentary Recruiting Committee (PRC), which put a lot of social and moral pressure on men to enlist. There were questions as to whether such 'advertising' could, and should, be used to raise an army. Advertising was seen as something questionable, damaged with the 'taint of trade', and used by modern businesses such as Selfridges to beguile and entice. However, the use of propaganda was necessary because public support could not be taken for granted. The British population had to be cajoled, encouraged and persuaded, rather than being forced. The state needed cooperation from its populace, whether serving in the armed forces or on the home front.

Propaganda was one of the most important defining features of the 20th century, and of its warfare in particular. Since the early 20th century propaganda has been defined as information, ideas and opinions that are propagated as a means of winning support for, or fomenting opposition to, a particular cause. The word 'propaganda' itself is Latin in origin, meaning 'to sow' or 'to propagate', and was originally seen as an innocuous and neutral term. It gradually gained more negative connotations, and by the end of the First World War it was regarded as a dirty word, as British citizens felt that they had been lied to in many of the messages. Propaganda in a democracy is essentially about getting people to change their own behaviour without compulsion, in the knowledge that it is for their mutual benefit. Whereas totalitarian propaganda is often backed by force and violence, democracies such as Britain need, at the very least, to give the impression that the target audience has a choice.

POSTERS: FORM AND FUNCTION

Before the First World War, the government largely limited itself to public notices, placed in civic spaces such as government buildings, schools, law courts and public parks. These notices informed and instructed by decree. During the war, as the realisation grew that it was total war and would not be of limited duration, it became evident that a different approach was needed – one of persuasion and education. The war poster was required to raise men, money, materials and morale. It offered an immediate means of communication, especially for the semi-literate and illiterate working classes who mostly fed the machinery of war. There was no commercial radio and no television, and newspapers were only for a literate majority, so posters were a strong instrument for reaching the masses.

At its most basic, the 20th-century poster could be defined as a paper sheet that was displayed in public, affixed to an existing surface and produced in multiples. It embodied a message and was not just for decorative purposes. The originator of the poster had a message to sell, while the target audience had to be persuaded to buy the message. That message needed to be conveyed concisely through a combination of words and images. 'Fougasse' – Cyril Kenneth Bird, a cartoonist for *Punch* from 1916, and designer of many well-remembered posters from the Second World War – offered much advice on how to design accessible posters that would convey their message effectively. Writing in 1946, he identified three obstacles that the poster needed to overcome: 'a general aversion to reading notices of any sort'; 'a general disinclination to believe that any notice, even if read, can possibly be addressed to oneself'; and 'a general unwillingness, even so, to remember the message long enough to do anything about it'.[1]

The poster therefore had three functions. Firstly it had to attract the attention of the passer-by, by ensuring that it stood out from its surroundings. It then had to persuade the viewer, not by trying to prove a point, but by suggesting the desirability of a course of action. Finally it had to keep the viewer persuaded for long enough to take action, through a single message that was simple enough for the viewer to re-describe to others. This simplicity needed to be balanced with the need to attract notice. Fougasse continually stressed the need to ensure that the viewer had a hand in decoding the poster by making the message only 90 per cent obvious, giving the viewer an incentive to work out the other 10 per cent. With their intelligence flattered, the reader would then take a sustained interest in that particular message.

The war poster, however, has a function beyond that of persuading the viewer to part with small change. In 1942, *Art and Industry magazine said* that a poster 'must inspire the

harassed and uneducated citizen to give five years or more of his life to make history ... Posters, however clever, are a waste of paper unless they kill Germans'.[2]

If a poster is successful, or even problematic, it stimulates discussion in the media, parliament, the pulpit and the public house. The poster artist is the interpreter and deliverer of a given message, rather than the initiator of it, so to criticize posters on an aesthetic level is to forget that they are designed to foster changed behaviour at the time of production, rather than as an art form. The conditions under which a poster is to be displayed are an important consideration. A poster designed for the road needs to be extremely bold and simple, while there are other places, such as bus stops, where a poster can carry more content. The London Underground is a special case in point. In the tunnels between lines and on the escalators, a single poster may often be repeated many times, as people are expected to hurry past rather than stop to look. On the platforms, however, some posters are very text heavy, as they can be observed in detail.

Of course, a good design ensures that a poster is displayed, without compulsion – essential in a democracy – and that it attracts attention before the viewer has had time to think about it. Tom Eckersley, who established his reputation as a graphic designer in the Second World War, felt that it was important for the poster designer to recognise the different needs and limitations of a poster, and to try to make the best of the circumstances. Posters worked alongside, or sometimes in competition with, other forms of media. Whereas there is choice for disengagement with other forms of media, it is hard to ignore a large, well-designed poster.

By rights, a poster should be obsolete once it has fulfilled its original purpose, but over the years many posters have been collected and stored. The fact that the poster began to be

collected as a minor art form may have encouraged some artists to produce designs with as much of an eye towards the collectors' market as the needs of the advertiser, but the original purpose of the poster is still key. Posters were always designed for public spaces. They are large and fragile, and often printed on cheap paper, which can make the display and handling of such objects difficult. Many posters tend to remain in museum drawers rather than on public display. Yet the poster often influences later ages as a historical document, as a reflection of its time, directly mirroring social and cultural change while offering insights into the ideas and images that characterised modern periods.

In 1917 the planning of a national war museum in Britain began. Designed to recognise the labour and sacrifice of the millions who had fought in the First World War by showing material from their everyday lives, and to give a sense of social cohesion to Britain's citizens, it included a War Publicity Collection. When the museum officially opened as the Imperial War Museum in 1920, it comprised over 20,000 items, including a wide range of wartime posters.

FIRST WORLD WAR POSTERS

In their book on First World War posters, Jim Aulich and John Hewitt note that government decrees were no longer enough – education and instruction was required as the government regulated more of people's lives. People needed persuading that they were fighting a just cause, defending a community in which all had an interest: 'For the Allies, official campaigns were … aimed at the individual serviceman and citizen as opposed to the state and nation, including the 40% of British troops fighting who didn't even have the vote, creating a space

where they could find a form of representation denied by the nation.'[3]

It was clear that there was some discomfort from certain sections of society regarding the use of posters in the public sphere, due to legal cases and to discussions undertaken in the media. Posters from the 1910 election had largely been framed illustrations of cartoons with captions, rather than designed in more commercial styles. Advertising was thought unfit to bear the moral weight of affairs of state, but the poster as a whole gained a new respectability for the way it supported the public cause of war.

This caution around the use of commercial tools for state business may explain why there was no Department for Information until 1917, which did not become a Ministry of Information (MOI) until 1918, and was swiftly closed down in 1919. Prior to this there were a variety of agencies which, constantly merging and splitting, sought to undertake the various functions related to morale, news, censorship and propaganda.

In the first two years of the war, 24 per cent of available men had been recruited. This is often attributed to propaganda posters, but regular pay for those in poverty, and other forms of patriotism, were the more likely attractions. Working largely without advertising experience, the Parliamentary Recruiting Committee (PRC) left it to the printers to develop designs as they saw fit. While printers seemed to be sensitive to the current needs and preoccupations of the populace, many of their designs were criticised for being poor quality, while others described them as 'bullying' posters.

The distribution of posters was managed largely through existing structures, including banks and post offices, particularly useful for war bonds, while party political machines and municipal authorities assisted army recruiting offices in

distributing posters and leaflets for recruiting and war savings. Poster distribution in general was very haphazard, as most were sent out only at the request of local organisations. Posters could be as large as 36-sheet, but most were single-sheet in size (although difficult to see from a distance, they offered increased flexibility on placement).

The MOI was formed to instil some order into the chaos, and had been intended to control and influence opinion at home and in Allied, neutral and enemy countries. Prime Minister David Lloyd George hired, for political expediency rather than intent, those from the communications and press sectors who were influenced by early thought on the psychology of persuasion and advertising. Lord Beaverbrook from the *Daily Express* became Minister of Information, and Lord Northcliffe of the *Daily Mail* was hired as Director of Propaganda in 1918. Both saw the urban mass as irrational, responding to base instinct and visual messages. The focus, therefore, was on association and suggestion rather than 'good design'. Many committees for the new MOI used agencies, and those to whom design work was contracted out had quite a lot of freedom in their work.

Before 1916, when conscription was introduced, British men had been shamed into volunteering by implications of cowardice and loss of honour, with posters designed in a similar vein to the white feathers handed out to 'cowards'. Graphic realism was not very common, as death was to be sold 'like Bovril', with nice, healthy, cheerful placards. A belief in the cheerful, public-school atmosphere of life in the army was maintained, as censorship kept the realities of trench warfare away from the public. Circulating atrocity stories, such as those telling of the bayoneting of babies, do not appear to have shown themselves much in British posters. British efforts at atrocity posters were weak, and they comprised only a fraction of the posters produced.

Although the first war of the machine age, the First World War seemed to be represented as a struggle between men and men, with machines scarcely appearing at all. The propaganda style of previous wars – with proclamations, framed cartoons, and illustrations in the *Boy's Own* tradition – was still very much in evidence. The war was presented as a sports match between the British and the Germans, and glamorised in posters which used allegorical-heroic approaches, for instance through images that likened the activities of the soldiers to those of St George and the Dragon. Even realist images were romanticised – for example, images of soldiers going into battle with arms raised in salute were used (an attitude in which they were unlikely to have remained alive for long).

The poster had developed not only to sell the idea of the war to the public, but also to sustain it, despite the massive drain on life and money. Eric Kennington, an official war artist, noted that there was a careful balance to be struck with war poster design. If it was too positive and optimistic, the poster would be ignored by an increasingly sceptical public, but if it was too realistic, it would damage civilian morale.

With fears of revolution after 1917, government called for organised public persuasion. They started hiring space for official propaganda material, on sites such as those managed by London Transport, where the organisation's chief executive Frank Pick had originally refused to display government posters (especially those of the PRC), because of their poor design. To produce posters for London Transport sites Pick had hired some of the best artists of the day, including Frank Brangwyn and Gerald Spencer Pryse. They produced strong graphic realist designs, unlike the many government letterpress designs. By 1917 the declining market for product advertising, alongside paper rationing, saw billposting firms supporting the national cause and donating space on their hoardings.

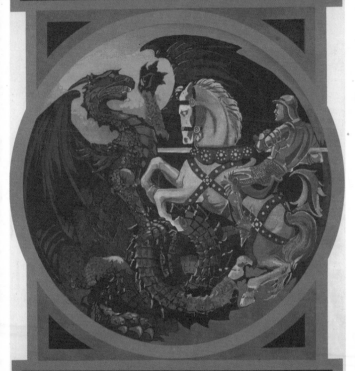

BRITAIN·NEEDS

YOU·AT·ONCE

PUBLISHED BY THE PARLIAMENTARY RECRUITING COMMITTEE, LONDON. POSTER Nº 108. PRINTED BY SPOTTISWOODE & Cº LTº LONDON. E.C.

Men were appealed to for dignity, honour and their patriotic duty to defend the home and family by joining the armed forces. Posters such as 'Daddy, what did YOU do in the Great War?', placing the man within the domestic space, challenged the viewer's masculinity because the home was normally seen as the space of the woman. The women's role was to pressurise their men into taking the commission, although later designs required women to be depicted in unusual gender roles, including the Land Army and munitions factories, alongside more socially acceptable work for appropriate charities. Vibrant images combined with emotionally laden appeals depicted the communal effort and the shared sacrifice to be made, with a sense that the whole community was at war, a noble cause was being fought for, and here was a space for YOU.

Personal pronouns such as 'You' were heavy, along with imperatives such as 'join', anchored in time to be 'now' or 'at once'. Posters addressed readers directly, encouraging a response from specific groups by highlighting that 'all your mates are doing it', and using colloquial terms and conversational elements to appeal to the widest group. People were addressed as dutiful citizens, loyal to King and Country, ignoring the realities of inequality as Britain and her allies fought to save 'civilisation', in which 'we' fought against 'them'. To help ensure total commitment, poster artists recognised the need to reach little-represented sections of the community and depict them in nationally defined roles, including women and the working class. A painless transition to the military was depicted for all, offering adventure, camaraderie, exotic travel, good salaries, and smart uniforms that would attract 'the ladies'!

National flags, popular contemporary figures, and historical heroes such as Nelson were common themes, along with freedom, democracy, individual liberty and national self-determination. Humour and stark realism were both used,

with fear believed to be a unifying force. On the home front, prosaic campaigns encouraged citizens to 'buy war bonds' and 'eat less bread', while savings were seen as key. Labour needed to be directed and organised, morale sustained, resources managed more sustainably (as excess consumption would aid the Germans), and relief charities supported. All citizens needed to be persuaded to work harder, and those posters which effortlessly affirmed British ways of life were the most successful with the public.

We cannot talk about First World War posters without mentioning the iconic Lord Kitchener poster, designed by Alfred Leete in 1914. The design that was accompanied by the phrase 'Your Country Needs You' was a magazine advertisement rather than a poster, and it was also printed early in the war as a widely distributed postcard. When it was reprinted as a poster – with the words 'Britons [Lord Kitchener] Wants You' – it was unusual in that it ran counter to the official tradition of recruiting in the name of the King.

There is no conclusive evidence to support the claims made by many historians that the poster version of Leete's cartoon was the most popular and effective official design of the war, but it has become a design icon in much the same way as 'Keep Calm and Carry On'. The image and layout have been reused, up to the present day, for various campaigns – ranging from military to economic, financial, political or educational.

JOURNEYING TOWARDS
THE SECOND WORLD WAR

By the 1920s art was becoming less of an exclusive domain, and graphic design became a respectable career option. The freelance designer was generally considered by contemporary

advertisers to produce better work, and had more prestige than the in-house team in an advertising agency. By the end of the 1930s, however, advertising agencies were taking most of the work, and advertising was subsequently criticised for too much standardisation and a lack of imagination. Freelancers were simply employed to complete the work that the agencies required. Consequently many designs are unaccredited and unsigned, a habit that remains for the many posters produced in the Second World War.

The increasing professionalism of the industry meant that campaigns tended to have more specific targets, with success measured by sales results, including the development of Gallup polls and Mass Observation surveys in the 1930s. During the inter-war period there were also state-sponsored propaganda schemes. The Empire Marketing Board (EMB) produced many posters, with designs purposely sober and restrained, to make the populace aware of the products of the Empire. In April 1931 Clement Attlee, as Postmaster General, instigated a large new campaign to foster 'telephone mind[edness]' for the General Post Office (GPO). In 1933 the GPO employed Sir Stephen Tallents, a senior civil servant with previous publicity experience, including the BBC and the EMB. He left after two years, highly critical of the posters used thus far. He felt that the artists did not have enough practical knowledge of the GPO's activities, mistakenly assuming that the GPO would want 'conventional' designs, and were therefore unable to promote the activities of the GPO fully.

In the contemporary era, we are so accustomed to media language that it often takes something shocking to make a new message stand out. By the 1940s, advertising professionals expected that a successful poster would contain at least some of the following features – continuity, flexibility, simplicity, appropriateness to subject, and the inclusion of a symbolic element. Generally, though, as the poster has developed, symbols and slogans – a form of shorthand requiring an easily shared phrase based on cultural understandings – have become the staples of the poster, although the government still had some progress to make as the Second World War commenced.

<u>YOU</u>R COURAGE
<u>YOU</u>R CHEERFULNESS
<u>YOU</u>R RESOLUTION

WILL BRING
US VICTORY

2

MAINTAINING MORALE IN
A STATE OF TOTAL WAR

■■■■■■■■■

'The people's war' was a contemporary wartime phrase, designed as a democratic and inclusive statement (and popularised further among post-war generations after Angus Calder's book *The People's War* was published in 1969). The people of Britain needed to be both physically and mentally prepared for conflict. A shared sense of national identity was key. The boundaries between the civilian and the combatant soldier were blurred, as propagandists attempted to define the entire population as heroic, whether serving as a 'citizen soldier' or as a 'courageous citizen'.

Early government papers from the Second World War show that the conflict was expected to be a war of nerves, where maintaining public morale was to be of primary importance. It was expected that intensive aerial bombardment would commence as soon as war started, with civilians involved in a way never seen before. The government would therefore have

to use 'every existing and conceivable type of advertising publicity and showmanship'.[1] Some government ministers argued that propaganda was a fighting service that needed effective funding, especially when up against German propaganda which had been built up over many years. The government could not 'afford to have the British public less united and less enthusiastic than the German public'.[2]

The two British prime ministers of the Second World War – Neville Chamberlain and Winston Churchill – were both unconvinced by the power of propaganda. They weren't prepared to rule it out, but neither expected great results from it. The Germans believed that propaganda effects were easy to measure, but a range of factors typically influences recipients of propaganda, including national feeling, friends, family, work, and other forms of communication, making it difficult to measure scientifically at either campaign or national level.

The social research organisation Mass Observation undertook summaries of morale, which demonstrated that it fluctuated wildly, from high to low, depending upon stories in the news. There were concerns that more news should be held back, but – particularly after the revelations of what had been withheld in the First World War – it was felt that knowledge was preferable to ignorance. As war continued, it was decided that exhortations were pointless, as people wanted direction and concrete orders. A feeling of the certainty of victory helped ensure that people would bear the burdens asked of them. Commenting in 1998, a historian remembered:

> Despite modern attempts at 'de-bunking', wartime spirits were mostly high ... We did not walk about with permanent smiles – in addition to the usual horrors of war ... times were hard, and there were invasion fears, bombs, V-1s and V-2s. However, there was never any

thought of surrendering ... we always thought we'd
win the war; and posters – like other official forms
of propaganda – played an important part in keeping
up morale.[3]

PLANNING TO LAUNCH:
THE MINISTRY OF INFORMATION

As war looked increasingly likely, planning for the establishment
of the Ministry of Information (MOI) in a time of armed
conflict started on 14 October 1935, with the formation of a
subcommittee of the Committee for Imperial Defence. The
First World War MOI had been disbanded as soon as possible,
as the governing elite found its work distasteful and 'un-
English'.[4] In the intervening years, as the communications
industry had professionalised, information activities became
a more normal part of everyday government practice. Many
information professionals believed that the efficient
management of propaganda would be key in the next war.
Despite this, initially it was left to enthusiastic volunteers to
do the planning alongside their full-time work. They were
provided with beer and sandwiches, paid for by Ivison
Macadam (who was to become deputy director of the MOI).
An illustrious list of publicity experts was also involved,
including from London Transport, Shell-Mex, the Post Office,
Imperial Airways, Kodak and the Empire Marketing Board.

Much of the planning was done in secret, as the government
was fearful of public reactions when seen to be using
'propaganda'. The first public mention of plans was in June
1939, in *Advertiser's Weekly*, which had consistently been calling
for more specialists and fewer bureaucrats in government
publicity. Sir William Crawford, founder of one of the leading

advertising agencies in the first half of the 20th century, wrote that 'propaganda is a drug' and a 'Ministry of Propaganda' was not wanted in Britain, although 'we might want a Ministry of Information, to give us the facts alone'.[5] The British, therefore, were much more circumspect than the Germans, who had the Nazi Ministry of Public Enlightenment and Propaganda. Britain settled for the Ministry of Information once again.

The MOI would be aiming at an entirely different audience to that of the First World War, one that was more directly concerned with the home front rather than simply recruitment. As Campbell Stuart, who had worked for the MOI in the First World War, noted when he resigned from the MOI in 1940, 'what had done very well for the Kaiser's war would not do for the Führer's'.[6] A new propaganda policy was needed, using the most up-to-date publicity methods.

The plans for the MOI were ambitious, apparently designed to include every possible channel of communication between the government and the people. It was expected that within a Publicity Division there would be separate sections dealing with each type of propaganda medium. The head of each section would advise whether a topic was suitable for their medium, and also suggest topics for which it was suited. It was anticipated that there would be a general section to determine all policy and to allot media in consultation with section heads.

In January 1938 a progress report established that a lot of work had been done, although when the MOI was mobilised briefly around the Munich Crisis in September 1938 (so-called because of the city where Chamberlain signed an appeasement agreement with Germany to prevent war in Europe), it was evident that more was still required. The crisis highlighted questions over appointments, accommodation, links to the media, and the fact that relationships with other government departments were still unresolved. This raised the question of

whether the MOI could be left unformed until war had already begun, or whether it could form prior to war. There were problems with either decision – the former would lead to confusion due to a lack of preparation, while the latter effectively meant that the government had resigned itself to the inevitability of war (an impression they did not wish to give).

A plan presented by Sir Stephen Tallents to avoid the unpreparedness shown at the Munich Crisis was rejected, as it involved some takeover of the work of the peacetime departments. Blamed for the MOI's problems, Tallents was dismissed in January 1939 and replaced by Sir Ernest Fass, a man with no real experience of propaganda. Planning largely went on hold until March 1939, when the Germans occupied Czechoslovakia.

After the Post Office established a public relations division in 1933, practically all government departments had established a press liaison section. The MOI expected to be seen as the centre for all Government war publicity – undertaking publicity for wartime departments, while peacetime departments were expected (initially at least) to continue their own work.

The existence of these various agencies was a major problem in the formation of a centralised propaganda department in the Second World War. Each department wanted to conduct propaganda its own way, and objected to centralisation. They felt that those responsible for designing propaganda policy needed to have control over its production as well. Tallents and Sir John Reith (former director of the BBC) had called for a centralised department, particularly with regard to posters and films as they were deemed to be of a highly technical nature and required expert staff. Pre-war, the Ministry of Labour, the Armed Forces and the ARP all ran 'overlapping and wasteful' campaigns that competed for recruits, with each department explaining the campaign only from the angle of their interest.[7]

As the central governmental publicity machine, the MOI has been defined by many as shambolic and disorganised, unprepared for the start of war, as satirised in Evelyn Waugh's *Put Out More Flags* (1942), and later taken as the model for the Ministry of Truth in George Orwell's dystopian novel *Nineteen Eighty-Four* (1949). Like any wartime creation, the MOI underwent many changes, particularly in response to national press criticism. With many 'how-to' books produced during the inter-war years, suggesting that anyone with a measure of common sense and intelligence could be successful in advertising, the 'average man' also believed that, although he could not criticise the service departments, he could criticise the MOI.

More recent historians have argued that in creating a working propaganda organisation from scratch, the planners had recognised the public's need to be convinced that the whole question of government information would be in capable hands. Aspirations for the MOI wouldn't look out of place in contemporary marketing practice, with their recognition that persuasion could only be effective if it was in tune with ideas already held, simply nudging them a little further, or in support of appropriate legislation. It was believed that the citizen would need to be 'clearly and swiftly told what he is to do, where he is to do it, how he is to do it and what he should not do'[8] – a noticeably masculine notion of citizenship, reflecting the relatively new enfranchisement of women.

THE MINISTRY OF INFORMATION IN ACTION

The MOI was officially formed on the outbreak of war, with Lord Macmillan appointed as Minister of Information on 4 September 1939. He was succeeded the following year by Sir John Reith on 5 January and by Duff Cooper on 12 May.

Brendan Bracken took over the role on 17 July 1941, and stayed in post until Victory in Europe Day on 8 May 1945, successful partly because of his relationships with the press and – more importantly – Churchill.

Three main types of campaign were undertaken by the MOI. There were those that were initiated within, and conducted entirely by, the MOI. Paperwork from 1941 demonstrates that there were also campaigns undertaken by the ministry at the request of other government departments – including evacuation for the Ministry of Health, salvage for the Ministry of Supply, and 'Dig for Victory' for the Ministry of Agriculture. There were also campaigns initiated by Regional Information Officers. The MOI established whether or not a campaign was essential, and, if so, whether legislative or administrative action was necessary, with publicity providing the explanation. If legislative action was necessary but was refused, propaganda campaigns were rejected, as they were not considered a suitable substitute.

Once a campaign was agreed on, decisions needed to be made as to whether it should consist of explanation or a persuasive emotional appeal (which was considered somewhat overused). Any resistance to government requests needed to be understood, which Dr Stephen Taylor, Head of the Home Intelligence (HI) Division at the MOI from April 1941, defined as either material factors (food, warmth, work, leisure, rest and sleep, a secure base, and safety and security for dependants) or mental factors (belief that victory was possible, belief in equality of sacrifices, belief in the integrity and efficiency of the leadership, and belief that the war was necessary and just).

A Treasury ruling passed in 1940 required that all government advertising, other than that issued by the National Savings Committee, should be issued through the MOI. Some departments appear to have used the MOI only as a formality. There is evidence that, initially at least, the Ministry of Food

was prepared to work with the MOI. It understood that the role of the MOI was to defend the home front, and here food was a key target. The two worked in close consultation, with the Ministry of Food supplying information so that the MOI could prepare the appropriate publicity. The division of responsibility was explained in December 1940 as: 'most changes in *habits* (good or bad) are promoted by other Ministries, e.g. rationing, curfew … changes in *beliefs*, e.g. belief in official communiqués, are the direct concern of this Ministry'.[9]

The financial responsibility was unclear, as there was no scheme for the partial allocation of expenses, such as the production by one ministry and distribution by another. For example, if there were to be a general campaign against waste, anti-food-wastage posters would be part of the general scheme, and their cost would be borne by the MOI or the Stationery Office Vote. On the other hand, should the Ministry of Food decide to persuade the public not to waste certain special food commodities, the publicity would have to be financed by the department. A P Waterfield, a civil servant working for the MOI, regarded financial responsibility as an important issue as it determined whether the MOI was regarded as the 'mere servant' of other departments, or whether it should be regarded as a 'responsible department'.[10] The danger was that if departments had asked for a campaign to be given coverage and the MOI did not oblige, they would 'run campaigns themselves', when the MOI had felt that 'the absorptive capacity' of the public had been exceeded.[11]

By May 1939, planning staff had been employed in the MOI's General Production Division (GPD), including a manager to coordinate technical planning, an assistant with a specialised knowledge of outdoor publicity, copywriters, research workers and a part-time artist to execute roughs. By mid-June the register of artists and collected samples of their work was ready, and

Let your SHOPPING help our SHIPPING

PLAN
YOUR MEALS
TO AVOID
WASTE

the first poster-roughs complete. In normal commercial practice, three months was considered usual from the decision to start the production of a poster to its appearance on hoardings. After consultation with His Majesty's Stationery Office (HMSO), it was hoped that it could be possible to effect the production of a poster in a fortnight, and once war had started, possibly in one week. In some cases this was achieved, with a campaign on behalf of the Ministry of Home Security printed and distributed within ten days of financial approval.

The GPD remained in place throughout the war, responsible for the writing and production of all printed matter, including articles, pamphlets, leaflets, books and posters. The GPD could, and did, call upon specialist advertising firms where necessary. For posters, newspapers and other publicity, the department acted as advertising agent to other ministries, and was responsible for a wide range of campaigns designed to meet specific requirements. The work undertaken in the MOI was intended to be that of review and control – it was not meant to undertake production directly itself, unless suitable external facilities were absent. The GPD included the understaffed Outdoor Publicity Department, where in 1941 the poster requirements of 19 government departments were being negotiated and handled by only 10 staff. Few campaigns operated without poster publicity, but £300,000-worth of paid-for poster sites and other voluntary sites was in the control of an understaffed department that was not being professionally maintained.

During the early part of the war, the MOI appeared unsure as to who exercised control over posters, particularly government and trade posters. The ministry did not have the power to change the wording of anything that passed through the department. In June 1941, the then Minister of Information Duff Cooper was driven to asking that the MOI be given more power or that it be disbanded altogether, as it was 'like being given a pitchfork

to deal with a tank'.[12] There was also the problem of 'Cooper's Snoopers'. From May 1940 the government, recognising the importance of understanding public opinion but cautious about using the perceived left-wing Mass Observation, started collecting information via the HI Division (including the Wartime Social Survey), to some resistance from the press, and possibly the public. In 1942 Churchill complained that HI reports could be written by a man sat in a London office, but this was met with a comprehensive rebuttal from Minister of Information Brendan Bracken.

To exercise central control, the Campaigns Division was formed in 1939. It ensured that all campaigns were given due priority, avoiding possible conflicts. Each campaign was planned to make proper use of all suitable media, with associated commercial and government groups protected from uncoordinated demands. Available advertising agencies were used, ensuring that government contracts were fairly spread. The division spent over half-a-million pounds per annum on poster site hire.

THE POSTER PRODUCTION AND DISTRIBUTION PROCESS

Edwin Embleton, studio manager for the GPD, was responsible for preparing contracts and ensuring that artists and copywriters fulfilled work on time – although one challenge was that artists weren't a reserved occupation (exempt from military service) until June 1942. He was loaned, along with ten colleagues from Odhams Press, to the MOI from 4 September 1939 until September 1945, and found himself fighting to keep experts on staff, constantly explaining the need for skilled understanding of poster design. Advertising specialists, although

they wished to remain patriotic, were earning half of what they could earn commercially, and as a result Embleton was losing skilled men, particularly as civil service rules did not allow for workers to take on other work in their own time.

Artists included Reginald Mount, who worked full time for the MOI throughout the war, and Eileen Evans and Austin Cooper, who joined later. Outside the MOI other freelancers were used, including Tom Eckersley in the Air Force, Pat Keely at the GPO, and Abram Games, the only 'Official War Office Poster Artist', with Frank Newbould as his assistant. The artists all maintained their identity as freelancers in a large design organisation, which appears to have positively nurtured creative work – although they were required to give up copyright, and many posters are not accredited with their designer's name.

Sir Kenneth Clark, MOI's Controller of Home Publicity, was given £100 (around £4,000 in today's money), which was expected to last six months, to pay artists to produce roughs. Payment would not normally exceed 5 guineas (£5, 5 shilling). Even Dame Laura Knight was only offered 10 guineas for a 'preliminary sketch', for which a further 60 guineas would be paid if the work was commissioned. The brief specified 8 ins (20 cm) for wording; the sketch was to be delivered within 10–12 days.

Designers recall it as a happy working time, designing for a serious purpose, and working largely without restriction. Outside agencies were employed on creative production by the GPD as much as possible, but practical limits were imposed, especially by the need for secrecy and confidentiality with certain material, combined with the need for speed and cost. It is unclear whether artists were commissioned or offered their services in every case, but the MOI was expected to get best value, and to a certain extent had to trust artists' judgements for the suitability of how they interpreted the message, rather than imposing a recognisable style as the Germans did.

Finished poster designs would be forwarded to the government-run HMSO (His Majesty's Stationery Office), along with the printing and distribution requirements. HMSO normally took about three weeks to produce about 30,000 coloured posters – colour was more expensive and time-consuming, but deemed more effective. HMSO were seen to have the best system for identifying which printing firms were able to take which type of work and when, and ensuring that works were of the required standard to be associated with the department.

Paper was rationed on 12 February 1940. With shrinking newspapers, more use was being made of posters on commercial sites by late 1941, with an average poster display using 17 tons for a 13-week campaign, and paper for colour printing requiring time to mature. The MOI had handled 18 major campaigns in the preceding 12 months, and noted that paper controls could not be allowed to interfere with crucial campaigns. Standard commercial sizes – particularly demy (30 × 20 ins, 76 × 51 cms) and crown (20 × 15.5 ins, 51 × 40 cms) – were to be used to ensure speed of production. Posters of a hoarding size were to be prepared only for long-term campaigns, while posters small enough to be used in shops were distributed in anticipation of, for example, food campaigns.

The government needed to ensure that it was not seen to be infringing the law, and the size of posters was limited to a maximum of four sheets (60 × 40 ins, 152 × 102cms) under 'Paper Order No. 16' on 25 May 1940. Government departments were not bound by the law prohibiting large-scale posters, but attracted valid complaints from commercial bill-posters on the score of wasting paper. In November 1941, further legislation was introduced forbidding the use of similar posters near each other. By 1942 government posters were to be displayed wherever free posting could be obtained, and where there would be pedestrian traffic or crowds.

Large agencies designed to manage outdoor publicity were employed to manage the poster sites, ensuring that they remained in good condition, and were put to the most effective use. On some occasions, it appears that the distribution process was not careful enough – appeals to 'save water' were regarded as particularly unnecessary near a Scottish loch with an inexhaustible water supply.

Distribution of posters was not fully centralised until August 1940, but it included factories, mills, banks, chain stores, licensed houses, hotels and restaurants, local authorities, employment exchanges, schools and post offices. Bulk distribution was done through the regional offices of the National Savings Association, the British Legion and the Boy Scouts Association. Urban areas were the most effective spaces for posters to be displayed, as the poster targeted large audiences with common experiences. Some poster designs were distributed with space for overprinting of certain messages.

By the Second World War, the chief point of public contact was the wireless, but the poster had the advantage of being hard to ignore. At the outbreak of war, it was expected that £185,000 would be spent on propaganda in the first two months of the conflict, of which £50,000 would be on posters. In 1942, £4,000,000 was spent on publicity (a 33 per cent increase on the previous year), of which £120,000 was on posters, art and exhibitions, with the MOI working as an agency for 18 government departments. In the first quarter of 1943, £1,724 was spent on artwork, and £37,455 on site hire, distribution and other costs. By 1943, 10 per cent of the entire MOI publicity budget was spent on the home front, of which posters comprised 4.32 per cent.

WARTIME POSTER THEMES

As we'll see in the next chapter, the first posters produced by the government weren't exactly a roaring success. The continuation of a First World War tradition in which a proclamation from the king was expected to bring everyone together was recognised as inappropriate for 'the people's war'.

A new message was required, and the government, alongside other organisations, presented a range of messages and designs as they sought to keep the people onside and engaged as 'active citizens' in the war. A concentrated message pervaded all forms of media, that of heroes on the home front doing their duty in working for the war effort. Constant parallels were drawn with the armed forces on the front line – whether at home, in the factory, or in some kind of reserved industry, there was no place for white feathers in this war.

An HI Division report in 1941 showed the need to publish peace aims, and there was a big question about what was the Britain that 'we' were fighting for. Soldiers returning from the previous war had ended up begging on the streets, and there was a belief that this couldn't happen again. This is best epitomised in the series of posters produced for the Army Bureau of Current Affairs, entitled 'Your Britain, Fight for it Now', in which Abram Games's posters drew on the 1942 Beveridge Report to present an optimistic future where housing, schooling and health were available for all, and Frank Newbould harked back to 'England's green and pleasant land' in a series of pastoral designs. Town and country were brought together in a variety of ways, including evacuation (which challenged their understanding of each other), the Land Army and 'Holidays at Home', which sometimes saw women turning up to help out on farms inappropriately dressed, as if for a picnic.

The heritage of Britain as an 'Island Nation' was called upon, including victorious figures and its 'proud' Empire legacy. The power of the church within culture was visible, both in the number of churches depicted in posters – especially St Paul's Cathedral standing defiant amid Blitz rubble – and in the moral messages evident in campaigns, such as those encouraging people not to spread or contract venereal diseases. Such messages were typically accompanied by less moralistic medical advice, encouraging citizens to keep themselves healthy in a time of war. In fact questions about people's understanding of sexual health had to be asked within a general health questionnaire, to encourage responses. Posting such designs up in public spaces like train stations caused controversy, particularly among parents who said that they didn't want to have to explain to their child what vD was.

Many posters sought to identify who was damaging the effort, whether deliberately or not, to fight 'the enemy within'. (Hitler or other recognisable leaders of the enemy typically represented the 'enemy without', rather than the German people, as inter-war travel had demonstrated that Germans were 'just like us'.) The enemy within was defined as that person who was careless, whether with their talk, their self-care, with saving money, or managing waste and materials. Princess Elizabeth noted 'how carelessly we should have talked but for Fougasse',[13] and even the press approved of the cartoonist's popular humorous illustrations, although much more serious designs were also available.

Appeals were made to comradeship, especially after the Soviets became allies in 1941 (this was not unproblematic for the government, who didn't want to encourage communism), indicating a sense of shared suffering, encouraging people to take care with the rations that they had, and to try new foods in order to take the pressure off the merchant navy. Austerity

was necessary as 'we were all in this together' (a notion that has persisted about the war to the present day). Within the communal effort, individual effort and sacrifice were seen as key. Those who didn't comply were stigmatised within poster images, but most designs were informational, and not backed up by threats in the way that Nazi messages were.

The wide range of posters, with much standardisation of design and format, was intended to reach the widest range of people. Languages included Welsh, Gaelic and Arabic. Local variations and school competitions were encouraged, as the messages increasingly called to common sense, offering necessary directions rather than exhortations. Photography was used occasionally – as in an evacuation poster remembered by Edwin Embleton, in which healthy-looking children smile into the camera – but most were graphic designs. Humour was typically used more than horror, especially on the home front. Images for those in the armed forces could be harsher, but in facing horrors every day, many wanted light relief and a reminder of what they were fighting for.

The government faced a challenge in depicting women, needing to represent them as patriotic whether at home or in the factory. There was a particular fuss over a poster produced by Abram Games in 1941 for the Auxiliary Territorial Service (ATS) – the women's branch of the British Army. The woman was deemed too glamorous, and off-putting for parents who might otherwise have allowed their daughters into the service, but the ATS said it was the most successful poster they had ever used. The design was replaced with a statuesque photographic image of Private Mary Roberts on parade in front of a line of soldiers.

Themes of 'never again' and 'never before' emerged, such as never again to return to the poverty of the 1930s, and never before was there such a moment to create a fairer future. The

growth of information services in wartime brought many of the intelligentsia who were concerned with the issues into a position of power. Churchill – wanting to postpone discussing future changes until the war was won, too concerned with fighting the war abroad, and not wanting to raise false hope – left the home front to Labour or Tory reform ministers, many of whom believed that war was also being fought against the conditions of the 1930s, allowing ideas of the 'New Jerusalem' unaccustomed power and influence.

THE END OF THE MINISTRY OF INFORMATION

From 1944 onwards, the *Daily Mail* and other publications were vocal about the MOI being wound up, to allow 'freedom of speech'. Despite press complaints, the MOI was thoroughly planned, and built upon extensive government and commercial experience. Clear administrative and production processes were instituted, and the importance of using suitable people – to produce the right message, at the appropriate time, in the best location – became clearer as war continued. However, in March 1946 the MOI, with over 2,000 staff under the leadership of the final Minister of Information, Edward Williams, was dissolved. Its residual functions were passed to the Central Office of Information (COI), an organisation providing common and specialist information services.

In 2010 the Behavioural Insights Team (affectionately known as the 'Nudge Unit') was set up to impact the behaviour of British citizens, and the following year, wanting to cut the government's £500-million spend on advertising and marketing by 68 per cent, the COI was closed down. It was argued that the system had become overly bureaucratic, had created an unnecessary layer of management spending, and that different departments could more effectively work directly with advertising agencies. Echoing the reaction of those who fought for the continuation of such a body at the end of the Second World War, those working for the COI expressed despair that 65 years of learning how to use marketing techniques to achieve policy outcomes and save millions of taxpayer pounds was being thrown away.

KEEP
CALM
AND
CARRY
ON

3

CREATING
'KEEP CALM AND CARRY ON'

■■■■■■■■■

It was impossible to predict what conditions would predominate during the first weeks of war, but it was felt necessary to prepare for the worst. The Ministry of Information (MOI) had to assume that the public would be subjected to an unbearable series of shocks, resulting in shattered nerves, a lack of confidence in ultimate success, and therefore a lack of will to work for victory – requiring plenty of general reassurance material. As one anonymous writer put it in *Advertiser's Weekly* in March 1939, 'the stout heart, courageous nerve and cheerful spirit can now do more to avert catastrophe than the fastest bomber or the biggest gun'.[1]

Despite doubts that it was possible to prepare effective propaganda in advance, the government started planning for the first posters in earnest in early 1939, and this is where we find the story of the creation of 'Keep Calm and Carry On'.

Although the government only archives about three per cent of its papers, there's a fairly clear record of planning and preparation pre-war in the UK's National Archives. However, the answer to the question that everyone wants to know is not clear – who actually devised 'Keep Calm'.

We know that the artist employed to create any poster roughs pre-war was a 'Mr Wall-Cousins'. This was probably Charles Ernest Wallcousins, born in 1883, who had previously designed posters for London Transport. The now famous slogan would have passed through various committees, with expert input from advertising specialists, over several months. Professor John Hilton, formerly Professor of Industrial Relations at Cambridge University, was responsible overall as Director of Home Publicity. William Surrey Dane, managing director at Odhams Press, and Gervas Huxley, the former head of publicity for the Empire Marketing Board, were tasked with making it happen on the ground, within a small Publicity Planning Subcommittee funded by the secret service. Also clearly involved in pulling slogans together were Sir William Codling, controller of HMSO; MP Harold Nicolson (married to Vita Sackville-West, and often misspelt as 'Nicholson' in paperwork); W G V Vaughan, who became Director of the General Production Division (GPD); H V Rhodes, who later wrote an occasional paper on setting up a new government department; and Mr Wall-Cousins.

PLANNING THE FIRST POSTERS OF WAR

In April 1939, members of the Home Planning Committee (HPC) were asked to come up with a selection of slogans and motifs from which to build poster designs. Unsure how much control it would have over other departments' publicity, the

MOI wanted its work to stand out from posters issued by other departments, and to 'bear a distinctive uniform device' – making it 'difficult or impossible for the enemy to print reproductions'.[2] Pictorial distinction was to be achieved by using leading artists whose work would be associated with the MOI, and typographical distinction was to be ensured by the use of a 'special and handsome type'.[3]

Initial designs were to include a message from the king, swiftly produced under war conditions as a simple proclamation. It was decided that the message should 'go out as far as possible in the form in which the King himself would send it', but using fine type rather than imitation typescript, and be plastered everywhere 'to drive the contents into everyone's head'.[4] Rather than a photograph, a crown would head the poster.

Proposing a short, single-sheet message, William Codling of the HMSO prepared suggestions in a suitable format, while Gervas Huxley suggested that 'We are going to see it through' would be more telling than 'England is prepared'. This poster was to be accompanied by a 'reassurance poster', which would 'steady the people and assure them that all necessary measures to defend England' had been taken.[5] The aims specified in May 1939 for the first posters were ambitious. It was agreed that the first poster slogan, supported by the pictorial design, should if possible 'attract immediate attention', 'evoke a spontaneous reaction', 'exert a steadying influence', 'incite to action', 'harmonise with general preconceived ideas among the public', 'be short' and 'be universal in appeal'.[6] Importantly, the initial poster was to stress an attitude of mind rather than an aim, as it was assumed that the public would appreciate the issues involved at the start of war.

By May 1939, the kernel of the first slogan was emerging around the word 'freedom' and the steadiness and tenacity required to preserve it. Initial suggestions included 'Hold on

for freedom', 'Defend peace' and 'Fight for the right'. Nicolson advocated that an initial, more formal design should be supplemented by a poster with a more colloquial appeal, such as one 'incorporating a historical progression from the medieval English bowman to the typical modern citizen'.[7] The abstract concept of freedom was deemed too academic for a nation in which 75 per cent had left school before the age of 14.

Posters would also cover the duty of the individual citizen (non-pictorial and in more than one colour), and warn against enemy propaganda. Another appeal along the lines of 'Don't let the others down' was suggested, as was the slogan 'Keep Steady', while 'Steady Britain' and 'Steady Britons' were to continue to commissioning stage. By this point Charles Wallcousins, chosen for his artistic versatility, was already undertaking poster roughs, and by mid-June, William Surrey Dane reported that these were now ready for inspection by the Chairman Ivison Macadam, along with Mr Cruthley, Mr Francis and Mr Rhodes.

Original plans were to commission up to seven designs, with expert advisers pressing for immediate printing of all of them simultaneously, to protect against the anticipated risk of bombing. The MOI, concerned that this could be highly wasteful in the event of policy changes, was happy to ask for authority to print from only one design – especially as the anticipated costs for national coverage on commercial and voluntary sites, through S H Benson's, would be around £112,000.

On 26 June 1939, in a specially convened meeting, it was agreed that £45,000 would be sufficient to cover 2.5 million copies of a single design, which could be adapted for varying purposes. The proviso was that another four designs were commissioned immediately, rather than waiting for the start of hostilities, as they were unsure how quickly suitable designs

could be produced under wartime conditions. It was agreed that the poster artwork should be of a high standard – at least equal to, or better than, the highest commercial standard – but that it should make an essentially popular appeal. As was good commercial practice, the first poster was to be in six colours.

Anticipated costs for the agreed print run of the poster were £20,600 for printing, packing and storing 5 million posters, and £225 for the design, with the remaining to cover a second print run. Figures were prepared by Dane, and were largely accepted by HMSO as reasonable. Fees to artists for design needed to allow for commissioned roughs and finished artwork, and adaptation to different sizes and proportions, including reproportioning of lettering.

DEVELOPING THE SLOGANS

In mid-June 1939, Dane had requested advice as to which of a set of 11 slogan headings should be prioritised (the first two were 'Keep calm. Do not panic', and 'Do not pay attention to rumours. Official news bulletins will be issued daily'). A month later, A P Waterfield, the career civil servant responsible for developing the MOI, raised concerns that posters along the lines of 'Keep Steady' and 'Keep Calm' were not inspiring, and implied that the nation was on the defensive. He called for 'a rallying war-cry that will bring out the best in every one of us and put us in an offensive mood at once'.[8] He proposed three approaches: a play on Kitchener with 'Your King and Country Need You *All*', appealing to 'every man, woman and child'; 'Your Courage, Your Cheerfulness, Your Resolution will Bring us Victory', conveying that it was the will of the nation that would win or lose the war; and, finally, a reminder that it is the task of the nation to destroy Nazism and everything it

stood for. Waterfield did not believe that he had the wording right for the first two, and he favoured the last idea.

Meanwhile planners had looked at First World War propaganda and noted the need to avoid 'we' and 'you'. More positively, later it was believed to be vital to show the interdependency of the country and its people with a slogan such as 'you depend on your country and your country depends on you'. A 'duty of cheerfulness' was expected as 'despondency lowers vitality, therefore those who depress others lessen efficiency and depress the war effort'.[9]

While the MOI was developing these poster slogans, they were making use of language that was already established. Laura Mugglestone, in the online 'English Words in War-Time' resource, notes how the notion of 'business as usual' has a long history in the English language, but once coupled with that of 'carry on', as Lloyd George had done in the First World War, it evoked a wartime mind-set. Conveying a determination not to give in, it created a sense of resilience and resistance, to continue as normal, whatever happens. Other recent research includes that by Henry Irving, of online resource MOI Digital, in which he notes that the stylised crown was borrowed from ill-fated plans for a 'Royal Message' to be sent by direct mail. The colours were chosen in the belief that the combination of red and white produced a psychological reaction (a notion borrowed from Hitler's *Mein Kampf*) – although designs in blue and green can also be found in the archives.

PUSHING THE POSTERS TO COMPLETION

As production could take a while, designs were to be printed and distributed regionally in advance, 'so that, when necessary, the posters could be placarded throughout the country with

a minimum of delay'. The initial posters were expected to be of 'an exceptional size', and to be 'displayed on more than ordinarily extensive sites', such as the sides of buildings.[10]

On 27 June 1939, Wallcousins had been sent a revised brief; by 6 July there was a selection of new designs with 'Keep Calm' among them; and by 13 July approximately 20 rough posters were ready for examination. These were whittled down to five to be viewed by the Home Secretary, Samuel Hoare, on 3 August – and it was he who finally decided on 'Keep Calm and Carry On', 'Your Courage, Your Cheerfulness, Your Resolution Will Bring us Victory', and 'Freedom is in Peril. Defend it With all Your Might'.

By August 1939 war was regarded as inevitable, and by 9 August the finished drawings were submitted to Ivison Macadam for final approval. Any adaptations to proportions could then be made and the posters printed. By 23 August, when Nazi Germany signed a non-aggression pact with the USSR, the proportions to be printed had been decided by Macadam and Vaughan. The percentages were: 'Freedom is in Peril' (for remote areas), 12 per cent; 'Keep Calm and Carry On', 65 per cent; and 'Your Courage...', 23 per cent. Treasury approval was given the following day for 3.6 million posters in 11 different sizes, from nearly 3 million at 15 × 10 ins (38 × 25 cms) up to 48-sheet (just under 3,000 copies). At around 700,000 copies, the double-crown – the size most commonly seen at wartime poster auctions – was the second most printed size. The costs were only £50 more than originally planned, although it was noted that 'Our fighting men depend on you' (for factories, works, docks and harbours) was also to be completed and printed as soon as possible, and that no allowance had originally been made for this. Final contracts were signed on 31 August, and production was still underway when war was declared on 3 September.

FREEDOM IS IN PERIL

DEFEND IT WITH ALL YOUR MIGHT

By September, 'Your Courage' and 'Freedom is in Peril' were already being posted throughout the country, with London receiving the posters first. On 7 September, it was minuted that printing of additional supplies of these two posters had already been sanctioned. Soon after war was declared, the small poster 'Don't Help the Enemy! Careless Talk May Give Away Vital Secrets' (also known as 'Anti-Gossip No. 1'), was approved by the War Office and was ready to put into production, at a cost of just under £8,000. By 17 September 58,000 copies had already been distributed. 75,000 copies were despatched daily from 26 September, with distribution completed by the second week of October. Posters were expected to be displayed for 8–13 weeks at a time, with a significant number of extra posters required for 'renewals' for outdoor display in order to keep sites in good order, combined with 'supporting press' where possible.

By the end of September 1939, roughs for further designs had been prepared and approved, including messages from the king and queen, designs specifically for factories and docks, and others specifically for each branch of the armed services (reassurance, not recruiting, posters). Posters were often stored in a roll, with the outside poster marked with blue chalk to indicate how many remained in the roll. On 16 November 1939, when an inventory of posters currently in stock was taken, there were still over 200,000 'Your Courage' posters, and 150,000 'Freedom' posters, but no more 'Don't Help' posters.

THE PHONEY WAR:
HOLDING 'KEEP CALM' BACK FROM DISPLAY

The first print run included nearly 2.5 million 'Keep Calm' posters, including half-a-million double-crown, and 1.5 million at 15 × 10 ins. In the first two weeks of September, it was noted

that 'Keep Calm and Carry On' was being 'held in reserve for immediate posting should the necessity arrive, e.g. immediately following a severe air-raid'.[11] But the expected air raids at the outbreak of war did not happen – instead, until Germany attacked France on 10 May 1940, the British people sat in what was described as 'the phoney war', waiting for military action on the Western front.

At the end of September Professor John Hilton noted, possibly in relation to 'Keep Calm', that 'my feeling is that we should go slow at the moment and reserve our main poster for the crash of the first air bombardment'.[12] Around that time it was minuted that two further posters were in the works, with the less politicised 'We're Going To See It Through' to be ready to replace 'Your Courage', and 'Britain to Hitler – No' in the event of a peace offer being received and declined.

Inevitably with a poster campaign that was planned before the war began, criticisms began. In response to a leader in *The Times* on 5 October describing the displayed posters as 'insipid and patronising invocations', Sir Edward Grigg was asked in Parliament about the expenditure on posters, and on whose advice they had been created.[13] The *Daily Express* header the day after Grigg's announcement of the costs was 'Waste and Paste'. Brigadier V M C Napier commented, via a letter to *The Times*: 'Is it wise, to say the least, to placard the countryside with posters calling on the courage and resolution of the individual when no appreciable demands have yet been made on these qualities?'[14]

On 20 November a meeting was held at which it was agreed that the 'Keep Calm' poster should be distributed to regional dumps in advance of any possible need. The possibility of distribution through banks, to be handed on later to voluntary societies, was discussed.

THE DISTRIBUTION OF THE FIRST POSTERS

Early on, the MOI anticipated that it would be able to use sites through the Office of Works, the Post Office, large companies such as WHSmith, London Transport, other ministries, and the National Savings movement, including for forms of transport such as buses. It was expected that the MOI should pay in the normal way for sites but, as was customary for a large order, seek preferential rates, and that posters could be on the hoardings within 24 hours once posters had been delivered to S H Benson's.

Smaller amounts and sizes were to be distributed to the GPO, schools, cinemas, works, cooperative societies, hotels, public houses and builders. The smallest sizes, up to double-crown, were provided to banks, van sides, shop windows and interiors, places of worship, hospitals and clinics, along with 50,000 of a special design for display in empty and wrecked houses. Voluntary, non-commercial sites were considered important, particularly in rural areas not covered by commercial sites. These included shops and shop windows, government and municipal buildings, village halls, women's institutes and private houses. Posters on these sites would be standardised to crown and double-crown sizes. The danger of using such sites, however, was the juxtaposition of official publicity posters with other miscellaneous posters.

Although in general the largest sites were most effective, small posters outside the newsagents' shops below eye-level attracted special notice as people were used to reading such placards all the time in order to get news. Factories and schools took the most 'Your Courage' posters, while 'Freedom' didn't go to schools. The National Savings Committee, licensed pubs, docks and harbours, fighting services and Civil Defence regions were particularly interested in 'Don't Help the Enemy!'.

THE RECEPTION OF THE FIRST POSTERS

Not happy about the formation of the MOI and its role in censorship, the press was particularly vitriolic about the first posters. Combined with the Mass Observation (MO) study, this has meant that the first 'red posters' ('Your Courage' and 'Freedom') have received a lot more attention subsequently than other designs, which may have been more popular, or more effective.

The MO study was initially commissioned by the MOI at the end of September to assess the general impact of the red posters and to report on any negative feedback, outlining specific reasons. It was completed despite the commission being rescinded on 1 October, as the MOI said it could no longer use outside agencies. MO drew upon observers working in Bolton and Fulham, anthropologically taking notes on people as they went about their everyday lives, in quite overwhelming detail, along with around 500 observers around the country feeding in via diaries or open-ended questionnaires.

For this report they interviewed over 1,600 people, and observed over 25,000 – noting that around 50 per cent of the upper class approved of the posters, as did 31 per cent of the working class. The following draws upon the extensive material contained in the Mass-Observation collection 'Posters'. Operating with no financial or official support, MO observers worked without authority and 'against the difficulty of spy-fear'. Some of the people they tried to approach called for the police. One observer referred to the 'posters advising people to keep their mouths shut'. Commenting on the same poster, another said 'saw one in the pub today and it said you had to give over talking about the war because there are a lot of spies about trying to pick up news', and added that it would be worse than being in 'Germany in a bit if we're not able to chat in pubs'.

More useful responses varied, with less than 2 per cent recognising the text as an extract from the king's speech. Some said that the crown 'caught the eye', but that it should be replaced with a flag, as it looked like either a 'by Royal appointment' notice or a tax demand. There were comments that the Germans understood the working class better, many noting that the posters were expensive and a 'waste of money' (bearing in mind that the first observations were done during the week that the figure of £44,000 for the posters was all over the press – with no realisation that this couldn't possibly cover the full cost of a poster campaign on this scale).

It was noted that there were usually two posters together, and that the red posters caught the eye better than the blue ones, especially in areas where war was affecting daily life, although it took some people a while to realise that there were two different designs. The words seemed to appeal to men more than women, with the largest posters getting the most attention, and younger people noticing them more than older people. The colour was one of the most-mentioned positive aspects, although negative descriptions included 'lumpy … like an aunt in a red flannel petticoat', 'bloody', and that the red was 'clearly to get the reds in'. Some surveyed said there was too much space on the poster for people to graffiti, particularly about Oswald Mosley's Blackshirts (named after the uniforms the British Union of Fascists wore), while others commented that 'if they're not convinced, a poster won't convince them'. A 25-year-old 'artisan man' is quoted as saying: 'They're bl**dy embarrassing. They reach the topmost pitch of sentimentality. They're couched in language which would have been all right in 1914, but for to-day it's sheer emotionalism. An appeal to practical common sense would be better.'

Several respondents to the current author's early research on wartime posters remembered the 'Your Courage' poster.

It was seen in the window of the butcher's shop in Eastleigh, Hampshire, 'on the way to school or work in Winchester', and in the engineering works, and it was believed to be the result of a political speech. The poster was clearly remembered in Barnstaple in Devon, where one man recalled that, as a schoolboy, his 'hometown ... blossomed with crimson posters' (the 'Your Courage' and 'Freedom is in Peril' posters). He remembered that they were much maligned, although the reason was unclear, and, in hindsight he believed that 'one could argue that the originator had, in fact, identified the three typically British qualities [courage; cheerfulness; resolution] which were to see us through the Battle of Britain and the Blitz'.

When the MO study asked people what they thought 'resolution' meant, most indicated 'determination'. In Bolton, as in many industrial areas, posters went to the factories first. Some said these were too big to do more than glance at them, and that they would have gone closer to look at small posters, but simply assumed that they were to encourage joining up. Artist Ashley Havinden noted that the fault often doesn't lie with the designer, as the task that is given is frequently too unwieldy to be communicated within a poster, and should be in a pamphlet or the press. The MO study noted that on these posters there were ten words each, including four possessive adjectives, two pronouns, seven nouns, four verbs, two propositions and an ordinary pronoun. Seven of the words had more than one syllable, one had more than three syllables, with four of the words very seldom or never used in everyday English. A journalist from the *Daily Mail* was critical of the 'Your Courage' slogan for being too complex; passing the poster six times every day, he was still unable to precisely remember the wording. The message had been impacted by sheer repetition, but whether it had been remembered in the right spirit was questionable: it still existed everywhere,

and was deemed mostly annoying and inappropriate for the wartime situation.

Some people found the 'Freedom' poster annoying in the face of increasing daily restrictions. Most popular criticism was directed at this poster, while the press and MPs focused on criticising the 'Your Courage' poster. The problem of 'you/us' within the wording was highlighted by several, who felt that it gave a sense of powerlessness to the reader as there were no actual instructions for anything to do. It was also taken to highlight the remoteness and non-understanding of government officials, which was not conducive to good morale, especially in the timing of the posters just before a budget in which taxes were raised. It was pointed out that the slogan 'Your King and Country Need You' had avoided such a defect and, in future, more care should be taken to avoid slogans that disassociated the civilian from the government.

Embleton in the GPD was impressed at the number of people who had noticed the 'red posters' within a short space of time. Commercial campaigns were expected to take time to have an effect, but by the beginning of October only one man in ten, and one woman in three, *hadn't* registered the fact of their existence. Most seemed to be remembering the gist of the posters' themes, with words such as cheerfulness, happiness, courage, determination, cooperation, helpfulness, fortitude, be calm, and be brave frequently mentioned. J M Beable, President of the London Poster Advertising Association, felt the MOI should be given due credit as well as criticism. They had acted quickly with the posters, working with the necessity for wording and design to be simple for prompt reproduction and quick absorption. The colour scheme was clever in contrast, both attractive and effective. He felt that the poster had succeeded in getting the public 'war conscious, war energetic, yet war calmly minded', as it had certainly been noticed by journalists.[15]

Possibly reacting to criticism that they had spent too much money on posters, in October 1939 the MOI decided to cancel the programme of press advertising and the use of commercial poster sites. Steps were taken to give publicity to the material already prepared, through designs suitable for voluntary poster sites. It was very unusual for any campaign to be on poster hoardings only – typically these would have been launched alongside a press campaign, in leaflets and on radio.

Government archives indicate that 'Don't Help' had been accompanied by a press campaign, but the media response to it was largely negative. MOI worried that, with the large majority neutral or hostile towards the 'red posters', an important medium had been discredited right from the outset. With very little feedback from overheard conversations about the posters, it was clear that they were not impacting on most people's daily lives. Whereas with successful advertising the slogan or sense of it soon appears in conversations, the press, and places of leisure in the form of good-natured parodies or further development of the same slogan, there had been practically nothing of this kind with the two red posters. One exception to this was a blue poster from Courage's brewery, with white letters and the Courage cock in place of the crown. It read:

> YOUR cheerfulness,
> YOUR resolution
> YOUR courage
> will add
> per 1d pint
> to the Exchequer.
> Strength and Quality maintained.

The results from the MO report were published, along with material on other government posters, in *Change No 2* for the

Advertising Service Guild at the end of 1941. Embleton found this report useful for the studio, as the MOI by this point had spent over £2.5 million on press and poster campaigns between the departments, with most on National Savings, then food, than MOI-specific campaigns. The report highlighted that the campaigns had too much pleading and not enough leading, although it was acknowledged that what people say out loud may not be the same as what they truly think. Responsibility for the failure of campaigns was placed squarely with the government as, in referring to later evacuation campaigns, it meant that either the people had not been made to feel the urgency of the message, or politicians were not using language that was clear and easy to respond to.

On 28 December 1939, Surrey Dane had returned to Odhams Press, as he believed that the task for which he had been loaned to MOI was complete. The last poster he produced was another careless talk poster, headed 'Warning', printed in various sizes, especially small sizes in the hope that it would be displayed on a voluntary basis in the interior of spaces such as factories and pubs. Once the phoney war was over, in 1940, *Advertiser's Weekly* noted that the nation had finally arrived at the point of 'courage, cheerfulness and resolution'.[16] People could now obey the exhortations of posters that had become all too familiar over 12 long months.

WHY WAS 'KEEP CALM' NOT USED?

In April 1939, the 'Lookout Man' in *Advertiser's Weekly* wrote that the test of a good poster was whether it was a thing that an ordinary human being would say – and it is clear that government planners were looking for a slogan within this vein. Ironically, the easiest to remember, as is now evident, was

the 'Keep Calm' poster, which was never given official sanction for display. By the time that Britain was subject to the Blitz, the MOI appeared to have taken on board the feedback, and realised that this kind of message was inappropriate in a war in which the nation was constituted through shared suffering.

Occasional claims are made, as by the *Telegraph* in 2016,[17] that the poster was seen on display (in a restricted area). As of April 1940, the Ministry of Home Security, preparing material for heavy raids, noted that supplies of 'Keep Calm' posters were held in readiness by regional offices. It is possible that some may have been unofficially displayed, but there is no record of this ever being officially sanctioned. Paper was short, particularly from 1943, and so it is likely that the remaining posters would have been pulped to use for newer designs.

WHAT DID THE MOI PRODUCE NEXT?

Alongside producing material for other ministries, the first MOI campaign to use commercial hoardings after 'Your Courage' was a design based on a speech by Herbert Morrison, Minister of Supply: 'Three words to the WHOLE NATION: GO TO IT!' This was also largely a text-based poster, although the

words 'GO TO IT!' were dynamically represented, as though moving at speed. Around 10,000 larger posters for hoardings and 200,000 smaller posters for factories and voluntary sites were produced for a four- to five-week run, again through Benson's. Government records indicate that discussions about material to improve courage and reduce dependency, in a vein similar to the pre-war planning committee conversations, were still evident later in the war. By August, however, government posters were being described by advertising experts as packing 'more punch', becoming 'less confusing', and having come 'a long way since unimaginative civil servants at the start of the war thought up the easily misconstrued slogan "Your Courage"'.[18]

4

REDISCOVERY AND LEGACY OF 'KEEP CALM AND CARRY ON'

■■■■■■■■■

I t is ironic that a design that was planned not to be easily reproducible has become a global design icon of the 21st century. 'Keep Calm and Carry On' has appeared on every high street, is sold in every tourist shop, has variations around the world, and is repeatedly brought out at times of national trouble. Nearly 80 years after the Second World War, there is still a huge amount of historical interest in all aspects of the conflict, while poster collecting continues to grow as a market. How, though, did a poster that was not even officially put on the walls during the Second World War become the most famous, the most copied, and a much-hated/loved design today?

POSTER COLLECTING

During the Second World War it was agreed that the Ministry of Information (MOI) would deposit MOI posters at the Imperial

War Museum – although this did not include 'Keep Calm'. IWM London has always displayed a number of posters within its exhibitions, and in 1972 ran a large exhibition. In 2006 IWM digitised 10,000 designs for online access. Most of the original poster artwork was deposited at the National Archives, who published the online gallery 'The Art of War'. The Victoria and Albert Museum and the London Transport Museum are among leading institutions which sell items based on their collections of highly visual material. (A postcard of 'Women of Britain, Come into the Factories' from IWM London in the early 1990s was what led this particular author to a study of wartime propaganda posters.)

Patrick Bogue from Onslows Auctioneers has observed that wartime posters started to see a market in the 1980s, and in the early 1990s Edwin Embleton, Studio Manager for the GPD, decided to sell his collection (he had kept a couple of each poster design for interest). Although anonymous, many could be identified by design style, including works by Dame Laura Knight, Roy Nockolds and Frank Mason. There were a lot with Arabic and Indian text, combined with simplified art for use overseas. A typical poster from Embleton's collection sold for around £100 – while the most expensive was Abram Games's 'ATS glamour girl', signed by the artist and the model, which sold for £1,100. Another collection from a former member of the Home Guard in Kent, who had saved a copy of every poster he was issued to display, was sold by his wife. This seemed to generate extra interest in what might be hiding in people's cupboards, and since then there have been other small collections of posters sold.

With the advent of the internet – generating more awareness of the availability and collectable value of posters, and enabling competitive online bidding – prices have doubled since the Embleton collection was sold. A typical poster now sells for

Crown Copyright means that the design was out of copyright, but permission needed to be sought from the owner of an original poster for the design to be reused. Barter Books claim that in 2007 a man named Mark Coop bought several posters from them, removing their name and then using the image on T-shirts and other products online. Legal efforts failed, although Coop's attempt to register the slogan as a UK trademark also failed.

'KEEP CALM' AND ITS VARIATIONS

At the premiere of *Harry Potter and the Order of the Phoenix* in 2007, actor Rupert Grint was given wide exposure wearing a 'Keep Calm' T-shirt sourced from lifestyle brand Yes No Maybe. He then auctioned it off for Cancer Relief. By February 2009 we were reading that British Prime Minister Gordon Brown had the poster pinned up on his wall. Presenter Chris Evans wore a 'Keep Calm' T-shirt on the flagship BBC programme *The One Show*, as did James May on another BBC show, *Oz and James Drink to Britain*; while dance rehearsals from *Strictly Come Dancing* (also BBC) featured celebrities wearing variations. With online retailers like ASOS (formerly As Seen On Screen) tracking celebrities' every move, and eBay and Amazon in mainstream use, it had become easy for fans to track down what their favourite celebrity was wearing, and order their own copy – including Max George from the hugely famous boy band The Wanted, who was spotted in 'Keep Calm and Grow a Moustache'.

A quick search for 'Keep Calm and Carry On' on eBay in 2017 still returns over 30,000 items for sale (most of which seem to be mugs), while Amazon boasts over 280,000 in the UK alone. A search of Google for 'Keep Calm' brings over 108

million results, the top two of which are 'make your own version' generators – a look under the images tab shows that people have been doing just that. My favourite unique design was created for me by a friend while living in the North-East of England (near Barter Books). Drawing on the Newcastle accent, the phrase says 'Divvent Fash Yersel' an' Gan On' and features Antony Gormley's sculpture *The Angel of the North* – which dominates the landscape at Gateshead, south of Newcastle – in place of the crown.

Famous variations include 'Now Panic and Freak Out', with the crown tipped upside down, or 'Panic Wildly and Run Away'. Matt Jones, a product designer with the British-based firm Schulze & Webb, was reportedly in a grumpy mood when he happened to read an article in the *Guardian* about the 'Keep Calm' trend. Pondering how the nation should find a positive way out of the recession, he designed 'Get Excited and Make Things', using a crown that included wrenches. The design became an internet hit. In 2009 'Keep Calm and Fake a British Accent' featured in a store window in San Francisco, and was quickly shared around the net, while during the swine flu pandemic 'Keep Calm and Don't Sneeze' appeared. The British police also got in on the act, using the same font and design with a blue background and a police badge replacing the crown, and the following slogans: 'We'd Like To Give You A Good Talking To', 'Anything You Say may be Taken Down and Used as Evidence', and 'You Have the Right Not to Remain Silent'. Designed to reassure people that the police were watching out on their behalf, it was interpreted by many as rather sinister.

More everyday slogans have included 'Keep Korma and Curry On' in Indian restaurants, 'Keep Calm and Party On' on student walls, 'Keep Calm, I've Kept the Receipt' on shop bags, 'Keep Calm and Store It' on a backup drive, and 'Keep

Calm and Feed Me' on a child's T-shirt. They have been featured on mugs, tea towels, condoms, seasonal decorations, calendars, motivational quote books, music recordings (a 2009 album by Stereophonics, and classical compilations), storage boxes, notebooks and other stationery, welcome mats, bunting, cufflinks, key rings and, it seems, every type of kitchen and garden ornament. They are used by charities (including 'Keep Calm and Volunteer Here'), featured in British Gas adverts, and the designs have been sold in every major supermarket at some point.

Add anything you are interested in to 'Keep Calm and…', and you are likely to find a version that already exists on the internet – and, if you're a women, to be knocked back by a sea of pink encouraging you to buy shoes, drink champagne or eat cupcakes. Knitters are encouraged to 'Keep Calm and Knit On', readers to 'Read On', tweeters to 'Tweet On'. Every faith has its own versions, as does every football team. You can buy for every occasion, maybe even forcing one with 'Quit Stalling and Marry Me', while engagements, birthdays, weddings and ordinations all feature; and you can thank the teacher, or encourage those running a marathon.

The design and layout has been used in political campaigns, in featured slogans from TV shows, and on protest marches. There have been Harry Potter- and Hello Kitty-themed versions in among the mix, while particularly noticeable are British versions that are related to tea. There are regional variations from Wales, Scotland and the Black Country, and global versions including 'I'm Italian, I Can't Keep Calm'. There have also been less savoury versions, including a problem with an Amazon seller's algorithm that enabled people to order T-shirts with variations such as 'Keep Calm and Choke Her'. On a more fun note, a box of bathroom matches known as 'Farty Lites' encourages its users to 'Ignite Stick and Hide the Stench'.

Throughout, the typeface – a sans serif close to Gill Sans, although suspected to have been hand-drawn – has become one of the mostly highly recognisable designs in the United Kingdom.

WHY SO FASHIONABLE?

According to British fashion historian James Laver, in his 'Laver's Law' published in 1937, something becomes 'charmingly fashionable' around 70 years after its initial production. The year 2009 was exactly 70 years after the 'Keep Calm' poster's production. In an online article that year, the BBC asked if it was the greatest motivational poster ever, as 'the very model of British restraint and stiff upper lip', working largely as a personal mantra, in the face of an uncertain world in which redundancy and recession was the focus rather than bombs and the Blitz.[1]

Comments under the piece indicated that many had found the poster slogan useful in times of family illness, redundancy and house moving, and for some it had even restored their sense of national identity. Barter Books, unimpressed with all the variations, held that the original poster would have 'resonance at any time'. Having sold significant quantities of the original poster to doctors' surgeries, hospitals, schools, army bases, embassies, government departments, and even to Downing Street, they felt it struck a chord anywhere that works at a hectic pace. The very 'Britishness' of the design was why they loved it in the first place – and probably why so many others do too. Fraser McAlpine, a writer specialising in content for American Anglophiles, notes that 'Keep Calm' is for Brits what 'I HEART NY' is to New Yorkers.

Jon Henley from the *Guardian* described it as 'the poster we just can't stop buying'.[2] Within the same article, Alain Samson,

a social psychologist at the London School of Economics, described the crown and 'message of resilience' as offering common values and reassurances, and a nostalgic response for a time 'when we all pulled together'. As journalist Owen Hatherley has commented, popular culture typically tells a story that supports a political narrative, for example British TV programmes such as *Downton Abbey* and *Call the Midwife* representing people as diligent and deferential. Rob Walker in the *New York Times* notes that 'Keep Calm' merchandise has sold well around the world, although 'each increases the distance from the original and simultaneously underscores its importance as a reference point'.[3] Mark Coop, who bought the domain name keepcalmandcarryon. com, noted that he sold a large number of Keep Calm products to Germany – particularly interesting, of course, when we consider the poster was created for a war against Germany.

The banking crisis brought a wave of orders from people working for American financial firms (in the US some still erroneously talk about it as the poster that kept the British going through the war). In newspaper headlines, the most frequent use for 'Keep Calm and Carry On' is to deal with a crisis – injury in a sports team, a petrol strike, stamp price rises, encouraging students to call helplines, or storms hitting the UK with typically understated 'Keep Calm it's a Bit Windy' in January 2012. The majority of academic journal articles using it as part of their titles are applied to crisis research, or those dealing with front-line health services, demonstrating a reaching out for a 'we can do it' mentality.

NOSTALGIA

Nostalgia is a strong force, often requiring a sense of meaning that can be shared. Professor Gary Cross writes that 'we long

for the past, no matter what our age',[4] claiming that the internet has made it easier to both build and sell collections of vintage memorabilia, or copies of them. The internet has also made it easier to mix, re-mix and share, with 'Keep Calm' quite possibly one of the most successful memes in history.

Nostalgia as a concept is fairly new. It was first defined as a 'longing to return home' in 1688, applying to soldiers who were serving overseas. It has more widely come to mean looking back to a 'time before', when things seemed slower and simpler. The railway and the telegraph increased the speed of and opportunity for travel and communication, creating a disdain for tradition and the old, as well as encouraging consumerism. As people sensed a growing feeling of transience, however, they started to become nostalgic for what had disappeared. The Romantic movement accelerated this by encouraging a return to pre-industrial traditions (as we see with the contemporary 'hipster' movement), some of which never truly existed.

Artefacts work best when emotional stories are attached to them, and for 'Keep Calm' this tapped into 'the blitz spirit' – something that Owen Hatherley in his book *The Ministry of Nostalgia* claims has been exploited by politicians since 1979, whenever they are calling for 'hard choices' to be made, often evoking the sense of 'shared suffering' of the war. He describes this as 'austerity nostalgia', seen to characterise the 1930s through to the 1970s, but which – for many who are drawn in by the poster – is not based on lived experience.[5] In his 1991 novel *Generation X: Tales for an Accelerated Culture*, Douglas Coupland terms this 'legislated nostalgia', in which a body of people are forced to have memories they don't actually possess. Commitment to the austerity regime was demonstrated by purchasing consumer goods, in the same way that George W Bush called for the American people to 'keep calm and carry on shopping' after 9/11, and through the subprime crisis.

The poster continued to feature in the media. In 2009 Anya Hindmarch, the designer of the 'I'm not a plastic bag' handbag, posed for a picture for *Vanity Fair* magazine in front of a large reproduction copy. It featured on BBC TV's *The Culture Show* in September 2010, and on the front cover of the satirical magazine *Private Eye* in April 2011. A year later Charlie Brooker complained in the *Guardian* that it was time to stop creating variants of the design, and footballer Dimitar Berbatov was booked for exposing a handmade T-shirt emblazoned with 'Keep Calm and Pass Me the Ball' when he scored the first goal. That same year I was interviewed for a German newspaper about the global spread of the phenomenon, and I took a trip (or was it a pilgrimage?) to Barter Books in Alnwick to see the 'famous original'.

KEEPING CALM LIKE THE ROYALS

Three big events in the UK provided a further platform for 'Keep Calm' and its variations – the royal wedding of Prince William and Catherine ('Kate') Middleton in 2011, and the Queen's Diamond Jubilee and the London Olympics in 2012. Cele Otnes and Pauline Maclaren's book *Royal Fever: The British Monarchy in Consumer Culture* uses the 'Keep Calm' design aesthetic for its cover, and insists that feelings about the royal family, with a lineage that is traceable back to William the Conqueror, are enmeshed within iconic aspects of national identity and heritage.[6] During the Second World War, for example, the then Queen Elizabeth (later the Queen Mother) expressed relief once Buckingham Palace was bombed, as it meant that they could 'look the East End in the face', if only symbolically. The royal family is an important part of the ongoing Anglophilia within the US, which identifies British

humour, especially irony and understatement, as key to the British character.

The 2009 royal wedding offered another opportunity for variations of 'Keep Calm' to be designed, sold, worn and shared – especially as William and Kate had limited licensed use of their image to 'permanent and significant' items (cardboard cut-outs notwithstanding). Flagship British store John Lewis was among many to provide objects, mostly with the 'official' slogan, while other stores provided interesting variations in the distinctive design and typeface, including 'Keep Calm, Harry is Still Single' (for all those dreaming of being a princess), 'Thanks for the Day Off', 'Crown Jewels', 'Wills Asked Me First, But I Said No', and 'Keep Calm and Kiss a Frog'.

At the Queen's Diamond Jubilee in 2012, slogans included the basic 'Keep Calm and Celebrate the Diamond Jubilee', the more interesting 'Keep Going Ma'am and Carry On', and 'Keep Calm and Reign On', alongside the more subversive 'Screw the Monarchy and Make Britain a Republic'. Later that year the London Olympics encouraged more variations, typically along the lines of 'Keep Calm and Go for Gold' and 'Keep Calm and Do Us Proud'. While in training, swimmer Kerri-Anne Payne cheered on her fiancé and fellow swimmer David Carry in a T-shirt that said 'Keep Calm and Gie it Laldy', a Glaswegian slang expression meaning 'Give it 100%'. Further iterations of the slogan were spotted in 2013 when Prince George was born, including 'Keep Calm, There's a Royal Baby on the Way' and to a lesser extent, when Princess Charlotte was born in 2015, with variations such as 'Keep Calm, the Princess is Here'.